CANNABIS FANTASY
COOKING COLORING BOOK

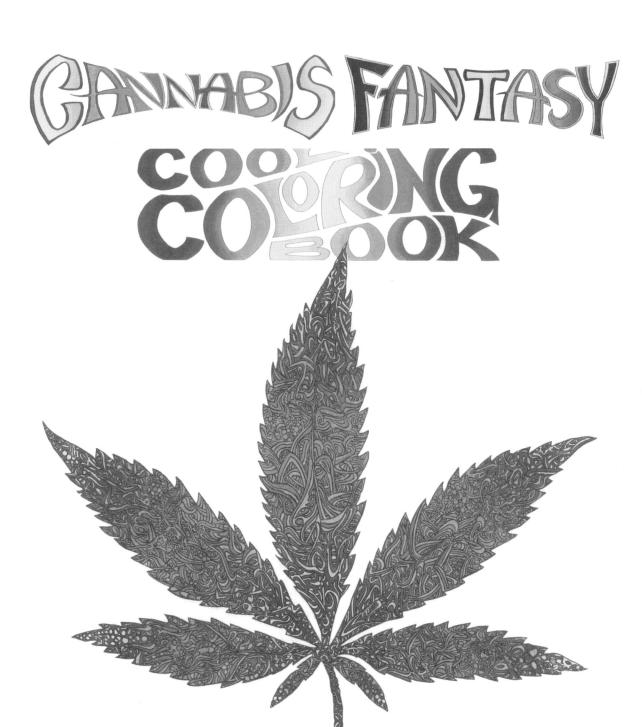

Published by Last Gasp of San Francisco
777 Florida Street
San Francisco, CA 94110
www.lastgasp.com

Cannabis Fantasy Cool Coloring Book
All images and text © 2009 Ré and Last Gasp.

Published by Last Gasp of San Francisco
777 Florida Street
San Francisco, CA 94110
www.lastgasp.com

ISBN: 0-86719-717-X
ISBN-13: 978-0-86719-717-4

First Last Gasp Edition 2009.
Eighth Printing
16 17 18 19 20 12 11 10 9 8

Printed in China.

My name is simply Ré and I welcome you to the next generation of coloring book - more intricate, more challenging and more thought-provoking. I've been creating with line, shape and color since I was a young boy growing up in Chicago. At an early age I attended the Art Institute of Chicago, becoming totally dedicated to art and the pursuit of artistic excellence. My favorite form of art has always been drawing. As an accomplished doodler I've always found joy in sharing my creations and encouraging others to be creative.

With the development and evolution of the "Cool Coloring Book" I want to help anyone who is willing to rediscover and explore the simple meditative art of coloring. After high school I attended the Maryland School of Art and Design, eager to learn and explore as many techniques and different media as possible. I discovered that printmaking was a great vehicle to more freely distribute my creations. Throughout my over 50 years of studying, training and executing many forms of art, nothing could teach me my own artistic reality; the way I interpret and recreate the world around me. Often I am not sure of what I "will draw" or even "am drawing." When I begin to create I just start and it happens. I also really like to erase.

After twenty years of mostly T-shirt art, I became a coloring book artist serendipitously. Since I always make copies of my drawings before I color them I had accumulated a large portfolio of over 100 line drawings. The *Cool Coloring Book* concept was launched in 2000 and has been evolving ever since.

Cannabis has always been a driving force to my creativity and achieving the "R mode" of creative flow. I have worked over the years with the Compassionate Use movement and for the legalization of all forms of hemp for all uses. These volunteer efforts have translated into visual imagery in my art and to my artistic lifestyle.

The 20 drawings in this volume contain a variety of complexity and skill levels are needed accordingly. You may choose a simple drawing (like the dragonfly) to start with as you build your coloring skills and ideas, or you may choose to tackle a more detailed drawing first. A magnifying glass might be helpful but either choice will require patience and the development of your own personal "color themes" and "schemes."

Using colored pencils or markers, feel completely free to experiment with different color contrasts, compliments, theories, transitions and mixed media. Add contrast with black, highlight with white, or even add your own original touch to the background or the drawings themselves. Share your coloring book with your friends, especially your finished, colored originals. Look for other "Cool Coloring Books" by Re' now in circulation and soon to come.

One last helpful hint before you begin - some drawings in this volume have hidden word messages, faces and symbols woven into the drawing; for example, look for the word "Love" in the profiled turtle. Before starting, you may compare the drawing you are coloring with the small, colored print on the back cover. If after that you are still unable to see the hidden images or words... perhaps some cannabis would help!

OTHER COOL COLORING BOOKS by Ré:

Extreme Dinosaurs Cool Coloring Book
$10.00

Dedicated to my dad, Bob.
Go forth and live as art...

Ré

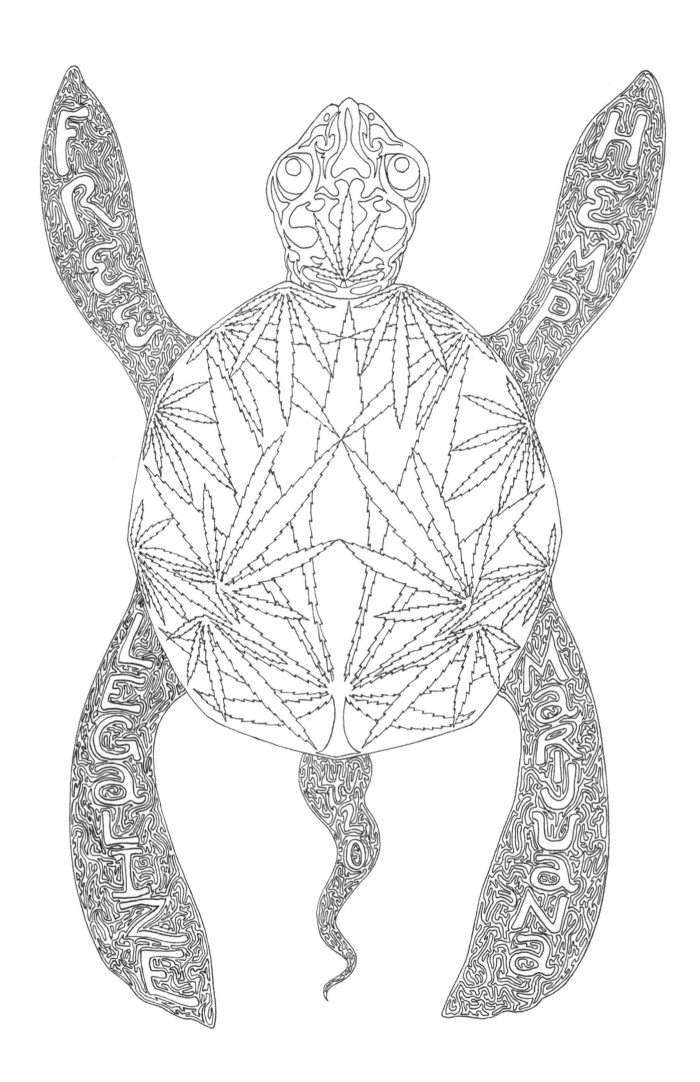

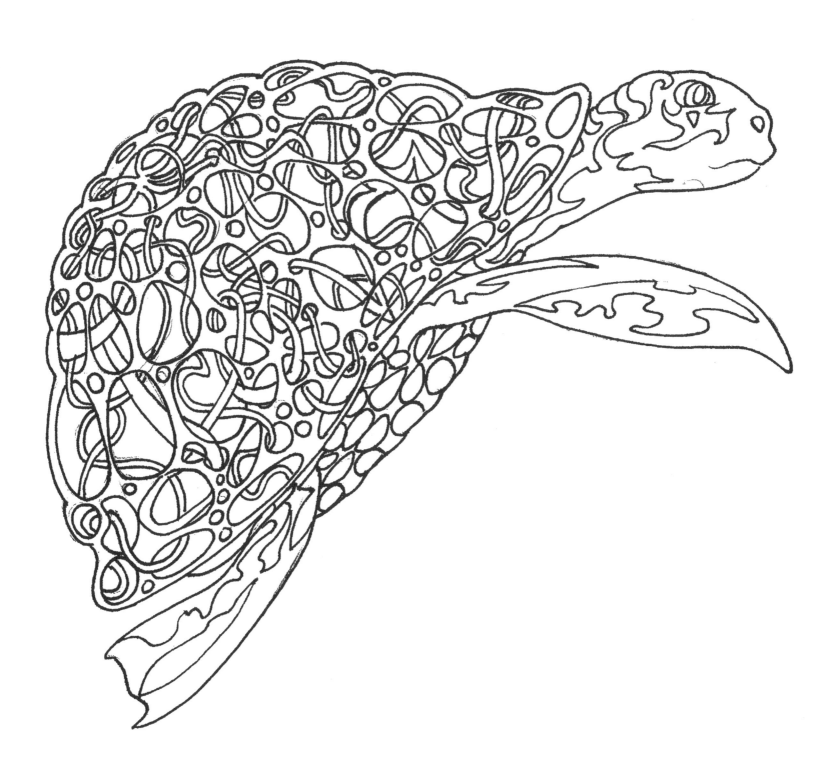

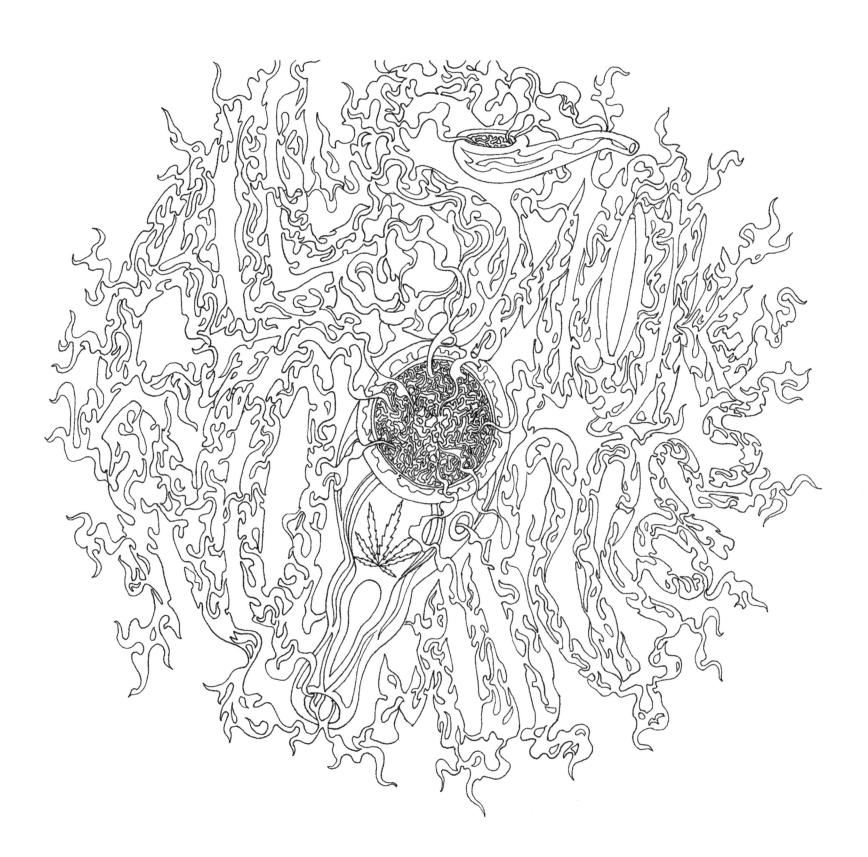

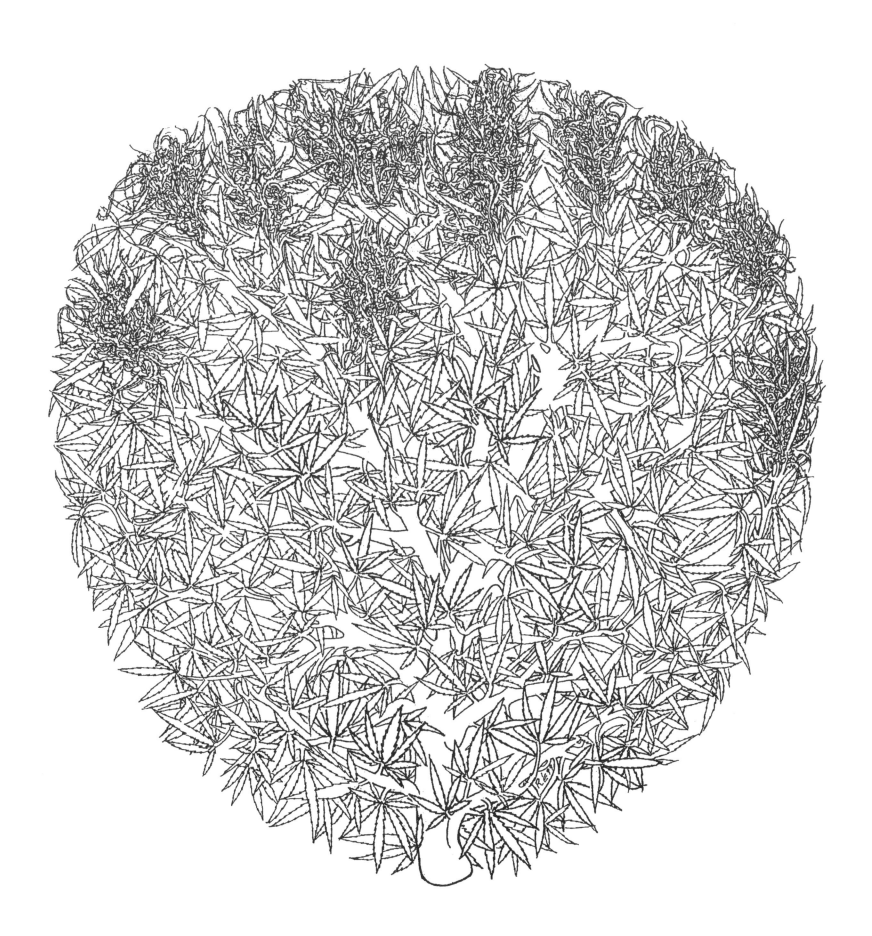

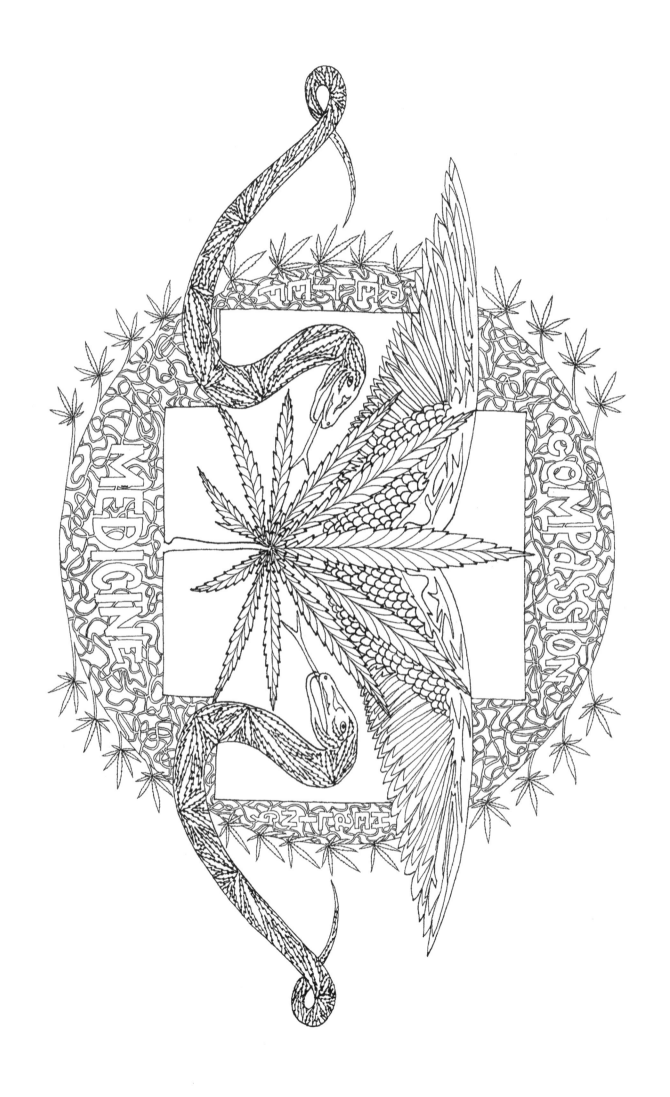

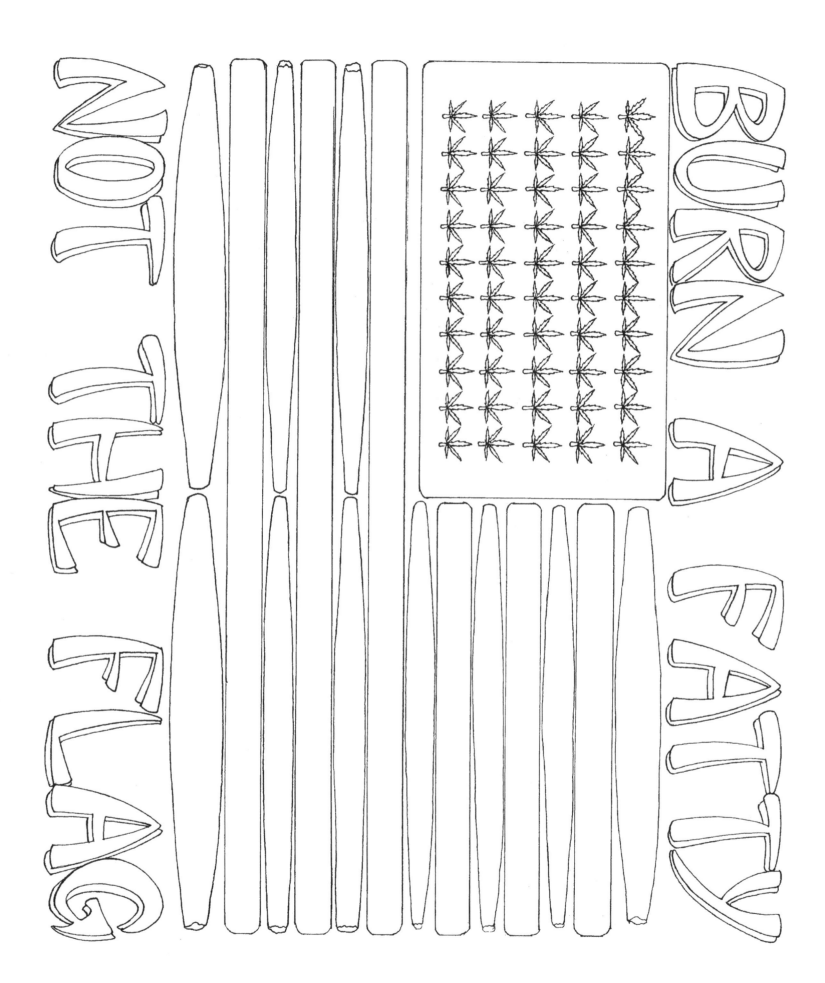

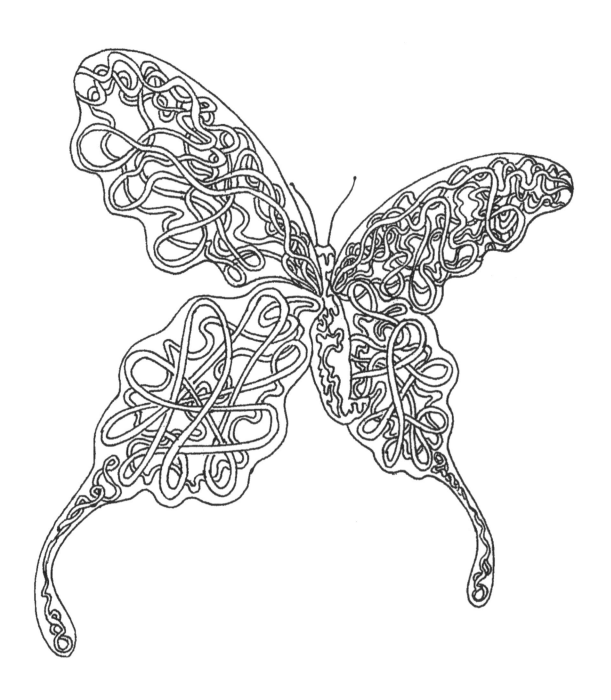

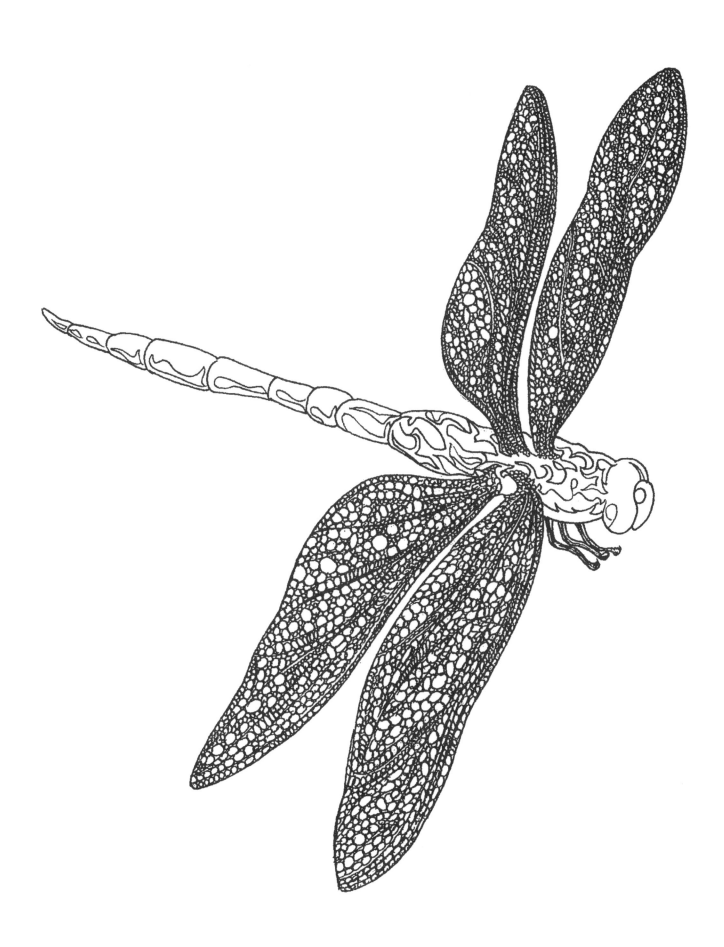

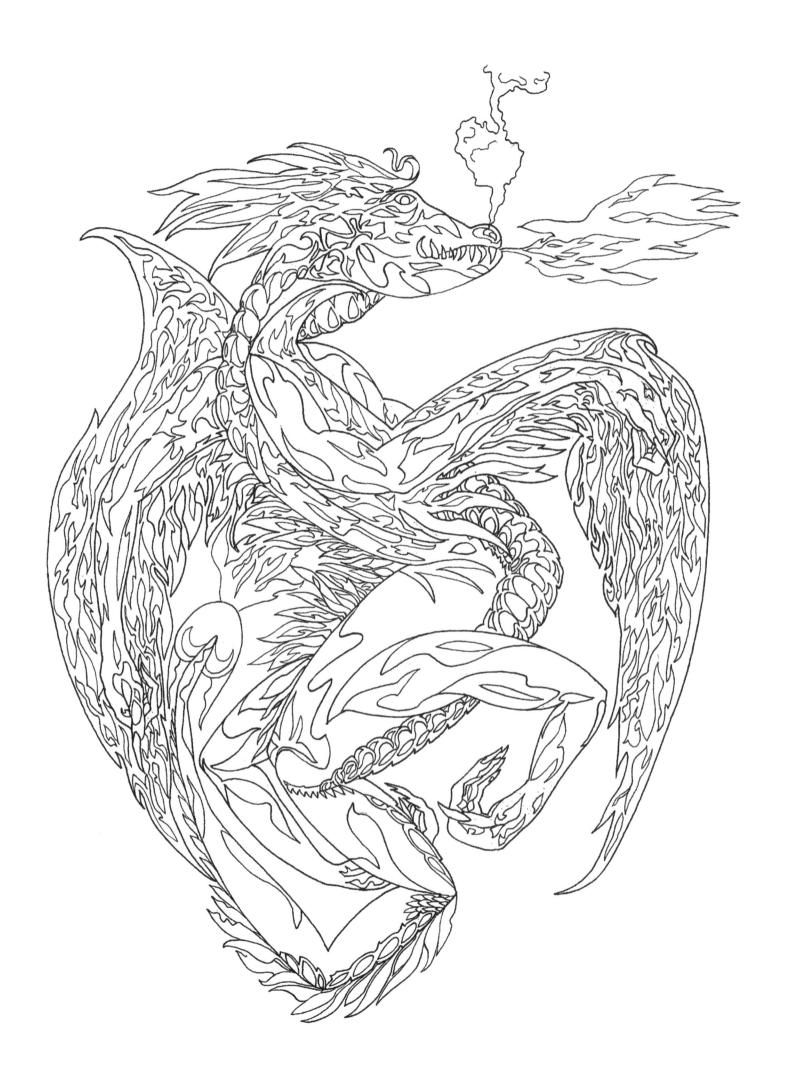

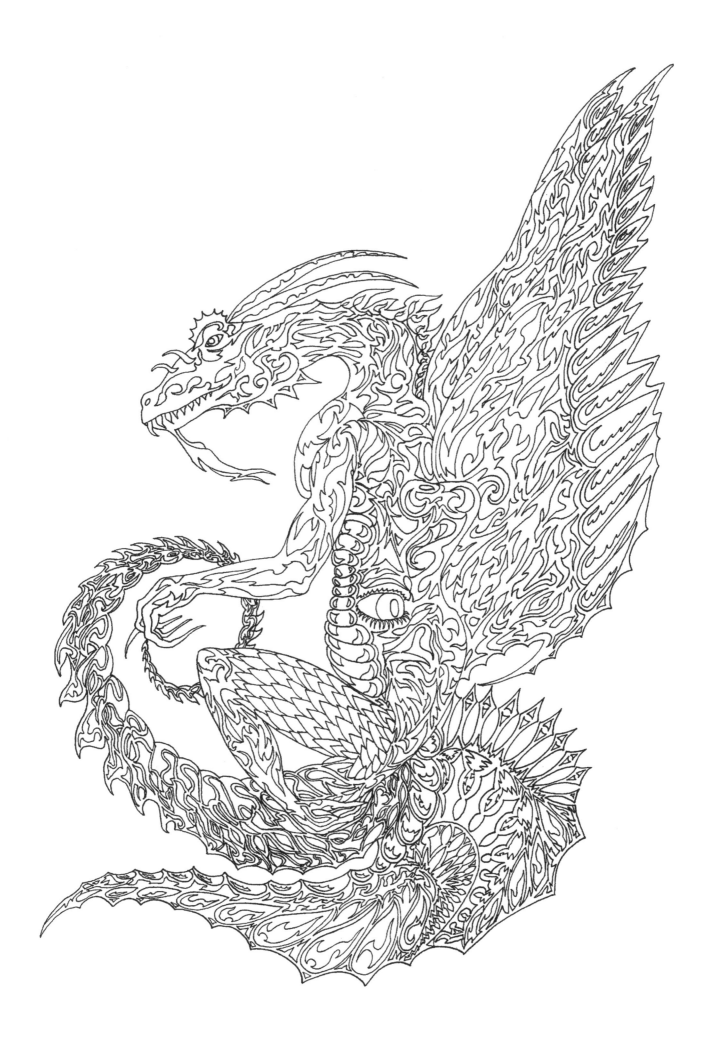

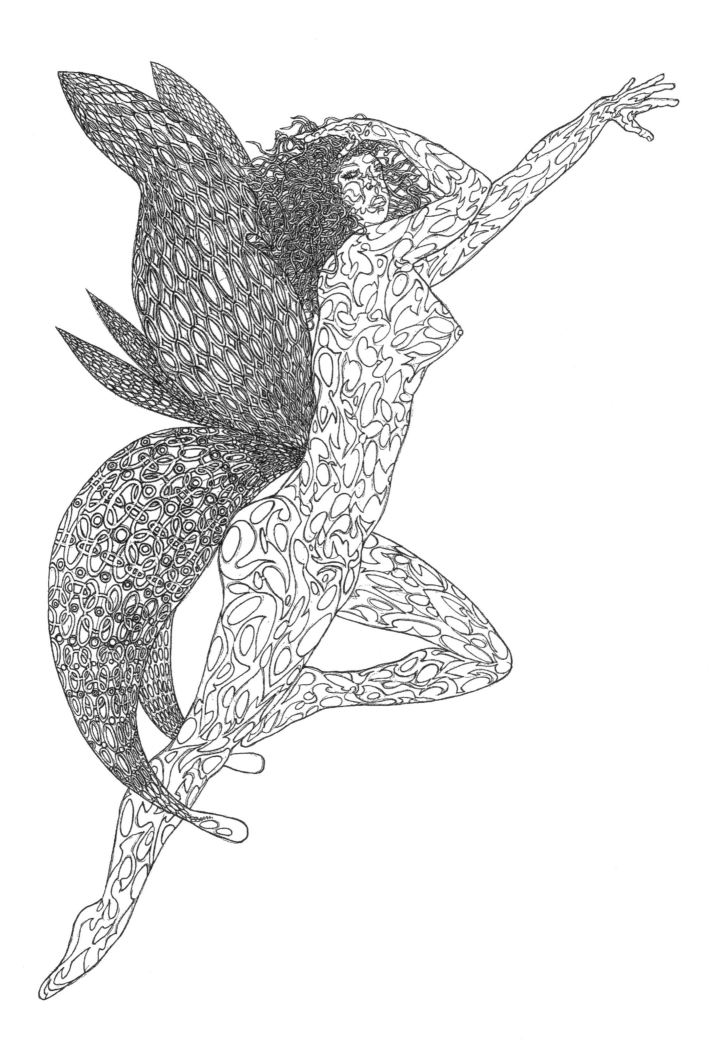

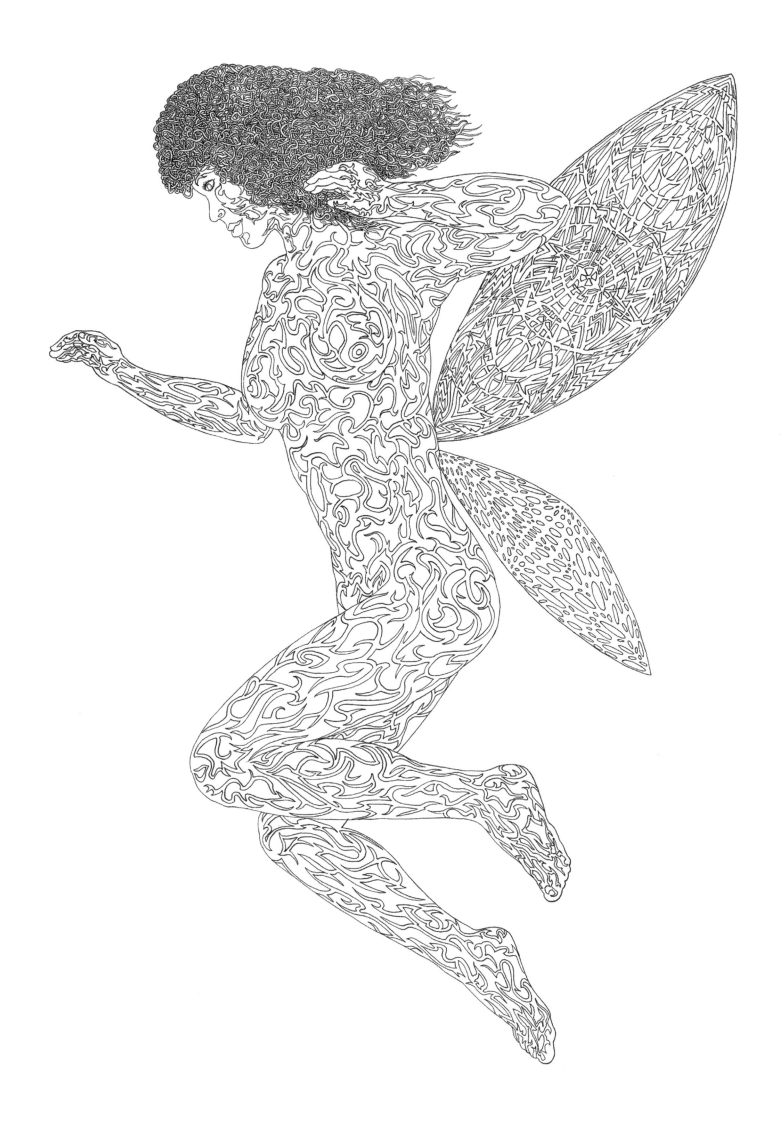

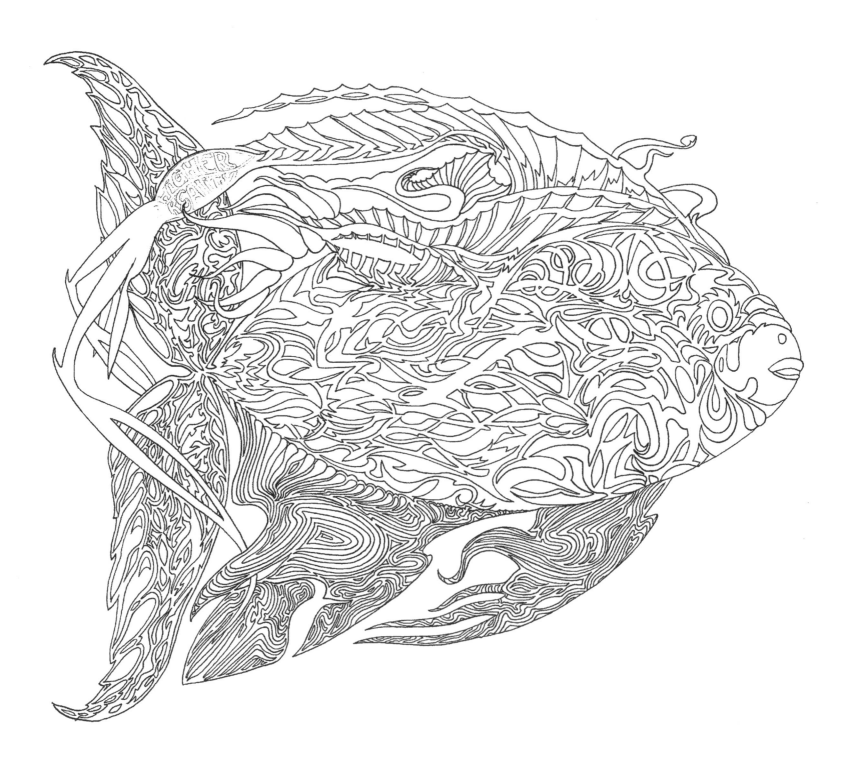

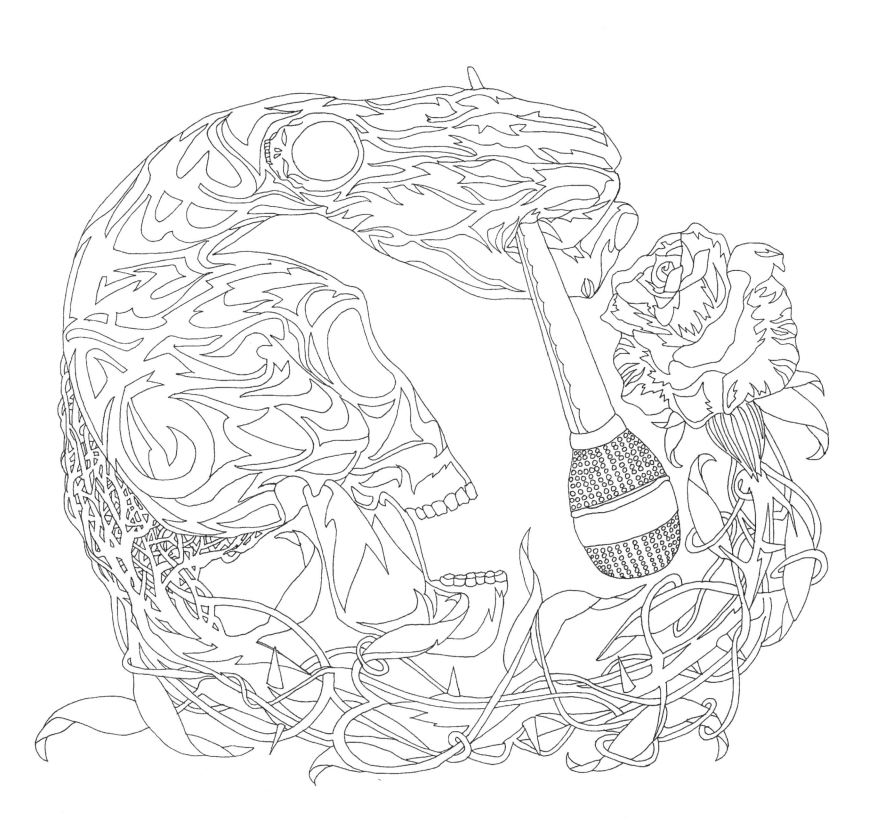

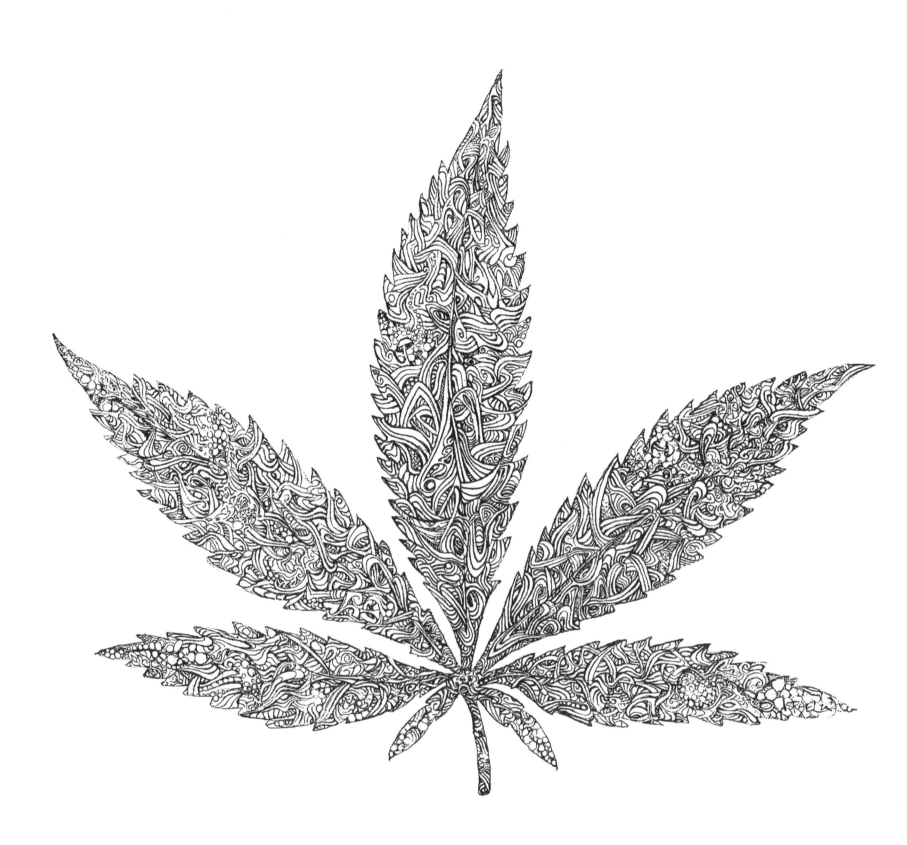

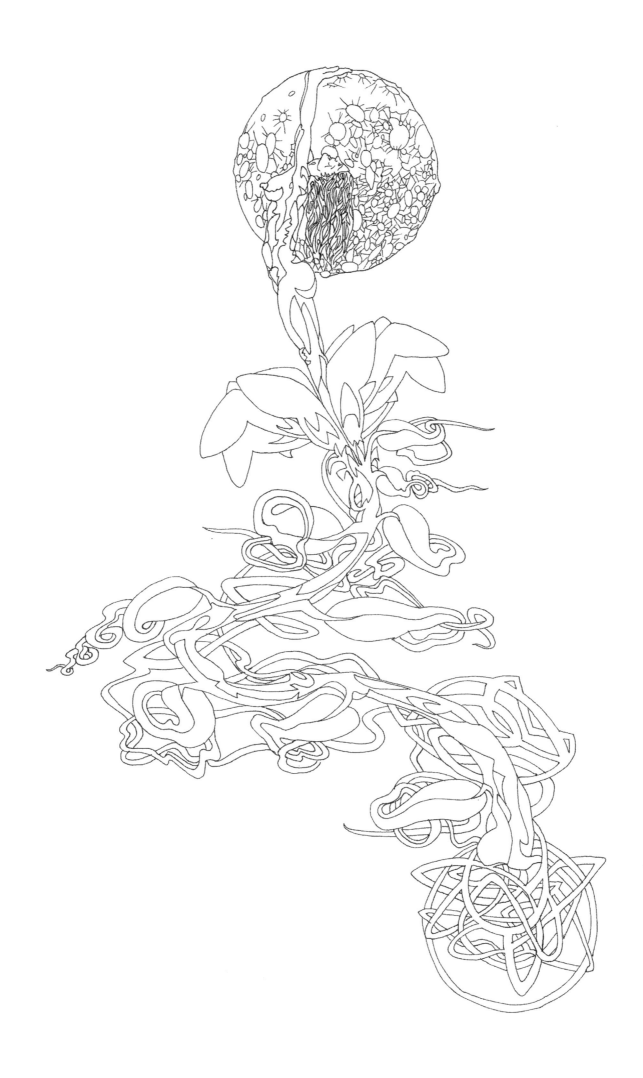

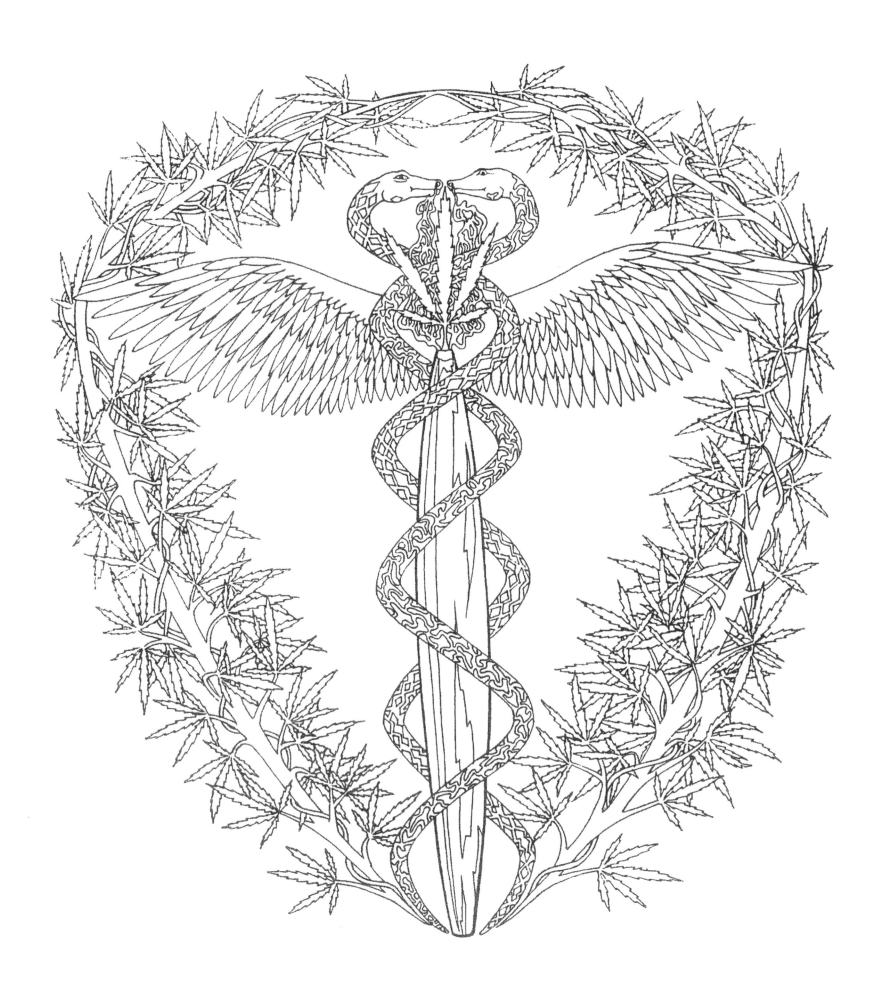

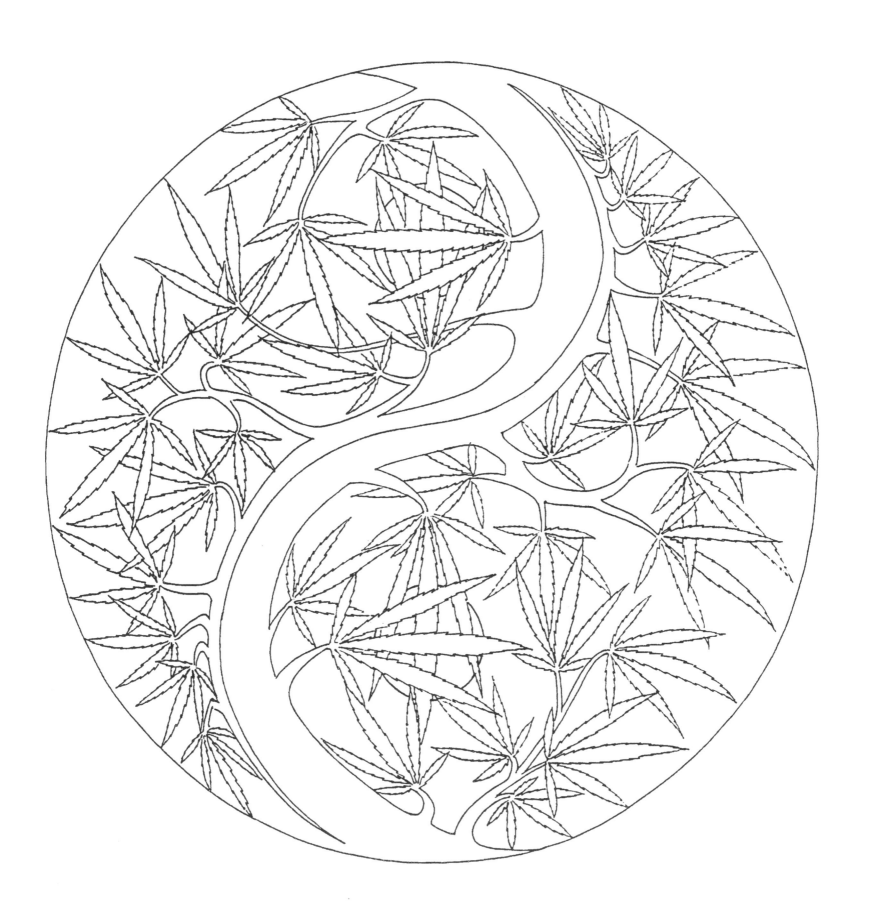

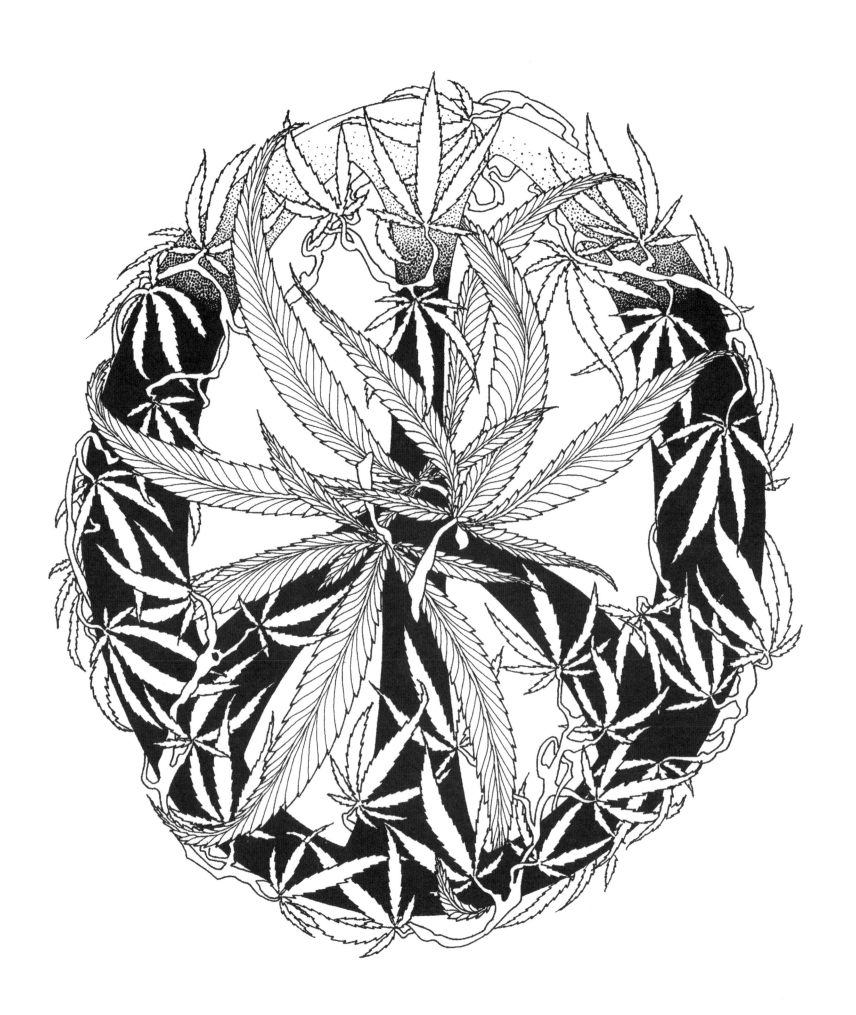

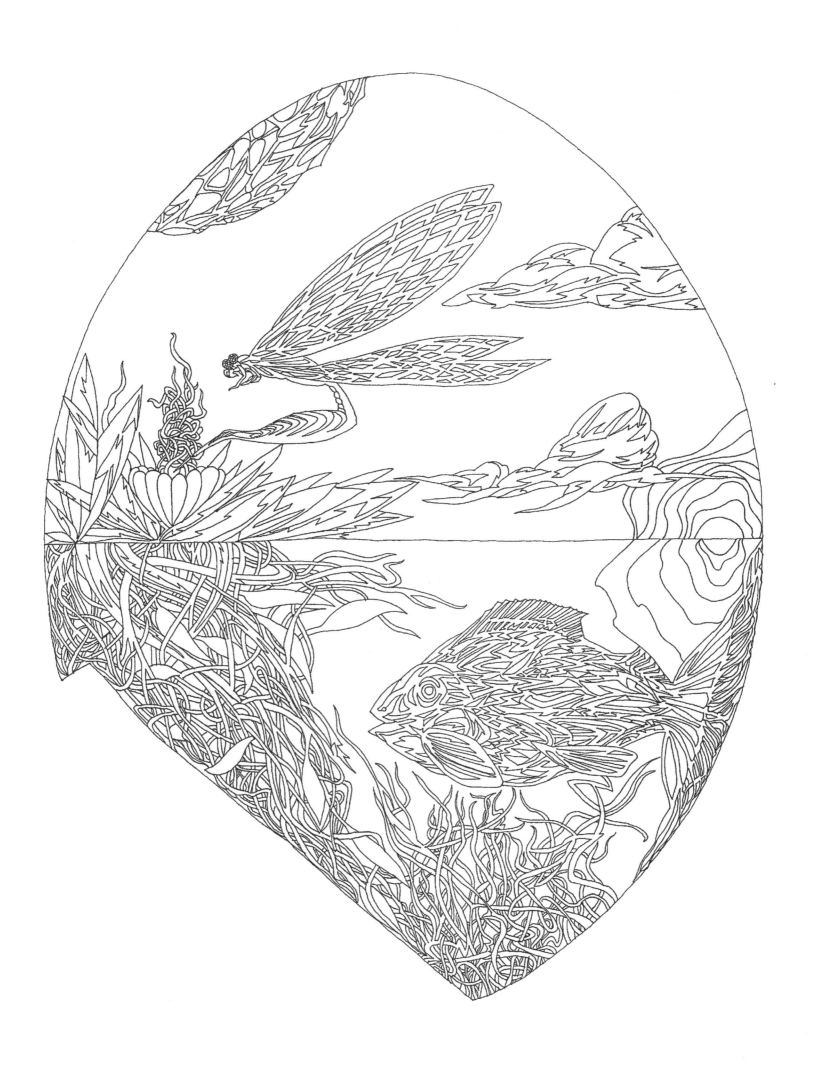